PAINTING CATS

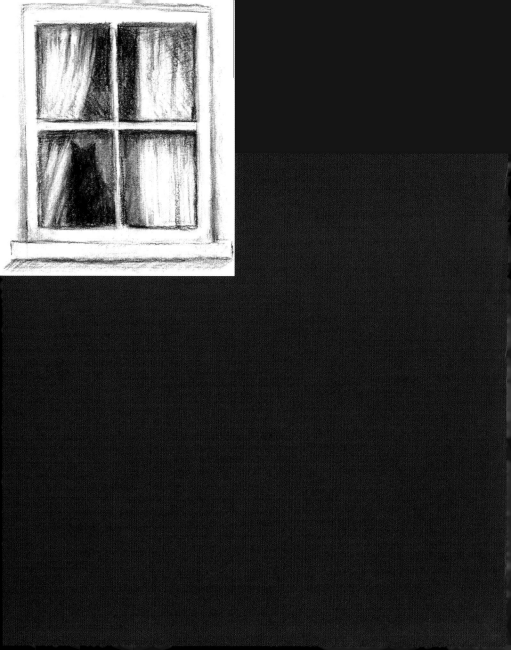

PAINTING CATS

DEBORAH DEWIT MARCHANT

with an introduction and poetry by
Marge Piercy

WILLIAM, JAMES & CO.
Wilsonville, Oregon
www.wmjasco.com

Publisher Jim Leisy
Design & Production Deborah DeWit Marchant
 Robert Marchant
 Tom Sumner

Rights and Permissions
William, James & Co.
8536 SW St. Helens Drive, Ste. D
Wilsonville, Oregon 97070

William, James & Company is an imprint of Franklin, Beedle & Associates, Inc.

isbn (paperback) 978-1-59028-208-3
isbn (hardback) 978-1-59028-228-1

Library of Congress Cataloging-in-Publication Data available from the publisher.

CONTENTS

FOR MY MOTHER AND HER MOTHER,
WHO TAUGHT ME TO LOVE ALL ANIMALS.

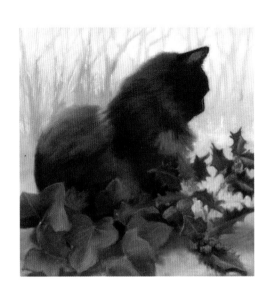

WHY DO WE COLLECT PICTURES OF CATS?
by Marge Piercy

DEBORAH DeWit Marchant belongs to a long tradition of distinguished painters who have found cats irresistible. Artistic depictions of cats over the centuries have run the gamut of styles and viewpoints: from ornately formal to whimsical, from literal to metaphorical, from worshipful to playful, from starkly realistic to syrupy and overly idealized. The unsentimental, sexy, streamlined drawings of cats by Theophile Alexandre Steinlen (1859–1923) are classic works of art nouveau. Germain Van der Steen (1897–1985) painted brilliantly colored, fanciful cats in action. Throughout her long life, Henriette Ronner-Knip (1821–1909) painted almost nothing but cats. Some of the best-known images of cats have been created by Japanese artists such as Toko (1868–1912) and the appropriately named Katsushika Hokusai (1760–1849). Deborah's contemporaries include the prolific and respected painter/printmaker Will Barnet and George Johanson, whose surreal/realist paintings often include cats as the magical domestic element in mysterious city views.

Cat images are all around us, and our appetite for more will not be satiated, it seems. Those of us who live with cats often seek to capture them with our cameras. Some of us buy calendars, mugs, bedspreads, sweaters, pillows with portraits of cartoon kitties, realistic cats or idealized portraits. Catalogs arrive offering for our mail order or internet delectation all kinds of items either featuring cats or designed to adorn or intrigue them. Why? Why do we cherish images of felines and why do artists spend so much time and effort painting or drawing them?

Though there are people who detest or fear cats, seeing them as aloof and treacherous parasites and predators, cats are the most popular household pet in the United States. Beyond that, many of us who start with one cat soon have more—not because we are careless and don't neuter our animals, but because they are more fun together. Cats who find themselves roommates may tolerate each other or form intense bonds that last a lifetime. They play together, sleep together, groom each other, chase each other, have spats and make up. They model our behavior in another key. They can be jealous, moody, angry, bored, affectionate, passionate, playful, sympathetic, empathetic. Some of my cats have exhibited a sense of humor, and every cat I have had has the capacity to lie to protect their dignity: a cat misses a leap and then pretends they wanted to settle down right there and wash themselves.

In my household, there are currently four of the nineteen cats I have lived with. Every one of these cats has had a distinct and strong personality. Each cat demonstrates definite personal preferences for food and play and sleeping conditions. Each cat likes to be caressed in her own unique way. They are small burning stars of personality and desire and quirkiness running around our living space.

In fact, any generalization you make about cats will be disproved. Cats are graceful: A Maine coon mix kitten I adopted from a shelter would, when she grew up, run into the room and trip on the rug. Some cats can pick their way through a jungle of perfume bottles and cosmetics on my dresser without knocking over a single one; others can't pass a vase without an accident. Cats are agile: Another rescued cat, Malkah, my apricot and white matriarch, thinks for five minutes or longer before jumping off a chair. She lands with a thud. Siamese are talkative: my chocolate point Efi, raised by orange Malkah, is mute unless you step on her tail or one of the male cats is too obstreperous. Chimps may exhibit a sense of self-consciousness by recognizing themselves in a mirror, but cats can't: I've had two cats who preened in front of mirrors and obviously knew who they were looking at. Both were Burmese, one male, one female. Both enjoyed their reflections. I have seen my male, Sugar Ray, look in a mirror, decide a hair or several is out of place and then groom, still appraising himself.

Those of us who love cats are addicted to their affection, their antics, their sensuous natures, their intelligence, their ability to train us. They boss us around or try to, they monitor every change in the household, they try to inform us of better ways of doing whatever we do. But beyond our affectionate connection, we love to look at them. Cats are beautiful. Even a cat not considered so by others will show its beauty in leaping, in chasing, in somersaulting. A cat in motion is fascinating, going from riding tops

The correct method of worshipping cats

For her name is, She who must be petted.
For her name is, She who eats from the flowered plate.
For her name is, She who wants the door always opened.
For her name is, She who must sleep between your legs.

And he is called, He who must be played with until he drops.
He is called, He who can wail loudest of all.
He is called, He who eats also from your plate.
He is called, He who sleeps in the softest chair.

And they are known as eaters and rollers in catnip
Famous among the nations for resonant purring.
Feared among the mouse multitudes. The voles
and moles also do run from their shadow.

For they perform cossack dances at four a.m.
For they stick their faces in your face and meow.
For they sit on the computer monitor to monitor your work.
For they make you laugh with their silly acrobatics

but their dignity is that of the oldest gods.
Because of all this we are permitted to serve them.
We are the cat servants, some well trained and some ill,
and they give us nothing but love and trouble.

—Marge Piercy
from *EARLY GRRRL: The Early Poems of Marge Piercy*, Leapfrog Press

of doors, running around cornices, leaping from counter to refrigerator top, climbing bookcases, and then to complete relaxation, as cats are also masters or mistresses of contemplation and meditation. I practice meditation regularly and always one or two of my four cats join me. They consider such inactivity quite sensible. Nothing looks as Buddha-like as a cat sitting with his paws tucked under and lightly crossed in front. Nothing suggests the bliss of sleep like a cat curled tail under head or one lying on her back with her paws stuck up like a four-poster bed.

Even the parts are a delight: the shape of the head, round or pointy or heart-shaped, the alert ears, the whiskers ever busy, the rosette of the paws, the soft mound of belly arching up to be rubbed, the eyes whether orange or yellow or blue or green, marvelous eyes that can glow green or red magically, the tail so sensitive that a cat can tell when your fingers make a loop around it, untouching. Their fur has so many beautiful colors and patterns, long or short or medium or curly, and is a delight to stroke. You can admire your cat for hours, and she wishes you would. Deborah's oils and pastels invite you to do just that. They are reminders of the natural beauty and unique companionship these animals bring to our lives. Some of her cats are inside, some outside, some almost hidden from us by a curtain or greenery; some are stalking or climbing, some are contemplating, some are sleeping, but all are true to their natures and pleasant to behold.

PAINTING CATS

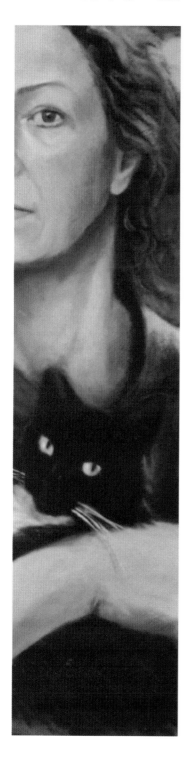

PAINTING CATS is a complicated business. Cats are not like other subjects. They are not like landscapes, or cozy lamp-lit interiors, or windows with a view. They're also not like reading or train travel. Those subjects, among others I've been preoccupied with and painted, tend to describe an experience people might have had or a place they might have been. Sometimes a metaphor is alluded to by a combination of objects and place in a painting, or some longed-for sense of tranquility is roused by a scene of nature. All these are imaginable things. But a painting of a cat asks viewers to relate to that cat and its circumstance, just as they might to a human figure. And herein lies the complication: We are not cats.

Many handy stereotypes help us relate, however. There is the hedonistic, finicky eater and the distant, arrogant beauty. In our collective imagination skulks the feline hunter who tortures its prey while in another corner of consciousness a sweet kitten plays with a ball of yarn. Conflicting, stereotypical images are born of a lack of intimacy with a subject. For a "domesticated" animal, the cat is bewitchingly inscrutable about its true nature, so we tend to describe cats as we believe them to be, not necessarily as we know them to be.

But getting to know cats is difficult, and a painter understands that depicting something one doesn't know is a presumption—like telling a story second-hand and portraying it as one's own. The nuances are lost, the little details that make the thing ring true blend with generalities and the essence disintegrates, like watered-down brandy. As an artist, it is the essence of things that matter to me, and so painting cats has required a certain amount of reflection on my own knowledge of the subject.

THE FIRST cat I lived with was named Smudge. She was a calico, and I only have a faint memory, a picture of her in my mind. We lived in a house on a lake in Minnesota. In winter, especially, the sun, low in the southern sky, streamed through floor-to-ceiling windows and spilled onto the living room carpet, making a radiant surface of warmth. My memory is of a beautiful puzzle-pieced red, black and white cat shape, lying in that sunlight, forelegs and hind legs fully stretched—an arc of glistening fur.

Smudge died of leukemia when I was about seven, and not long after my family left Minnesota and began a series of moves that led us, when I was twelve, to a humble and tired, very old white-planked house in New York State, which my parents rented. We were without cats after Smudge, though we did have dogs, terriers—good travelers but not temperamentally companionable with cats. In New York, hunting for a more permanent home, my mother and I found, abandoned in the basement of an unoccupied house, a cat with six very new kittens. The gray, pin-striped mother was clearly starving, and the kittens were likely soon to be. We had to take them with us, but where to keep them? I don't doubt the landlord was only reluctantly allowing us to keep dogs and would probably put his foot down at the addition of cats. The dogs, whose inbred attack response was awakened by any small, furry creature, would surely not be compatible at all.

We ended up raising the kittens and nursing the emaciated mother in the attic of the detached garage of our rented house. No heat, a single dangling light bulb, murky paned windows at either end of a dark and cobwebbed wood-raftered space, it was safe and dry. A ladder came up through a hole in the floor which we blocked off with planks when we weren't there. We furnished the space with blankets and pillows, boxes and stools. The kittens, a smorgasbord of tabby, ginger, black long and short hairs, climbed and rolled and mewed, stayed warm in a collective furry ball. They thrived. The mother grew fat and was forever grateful. With the adoption of seven cats it was assured that our family would never be without cats again.

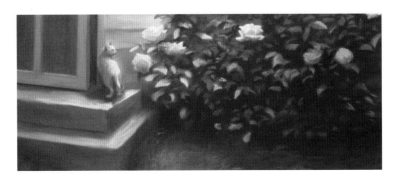

More cats entered my parents' and my life as the years went by. When I married, my husband even came with a cat, another calico, named Angie, with a personality quite unlike an angel's. She didn't like me and would trap me in the bathroom, threatening to take me out at the ankles if I tried to pass by her. With the exception of Angie, who my husband got as a kitten, all these cats were strays with unknown or sketchy histories. Some were old, some barely adult. Some afraid, some sick, some healthy and imperturbable. A couple of them were a little crazy, at least by human standards. All were immediately neutered or spayed, doctored if they needed it and asked to stay. None ever strayed again.

There was Whimsy, the favorite of my cat-loving father, who left his mark, a bloody gash, on my face when I startled him on the day before my wedding. (A conspiracy was suspected.)

Tinker, the little black-and-white long-hair who could always be found sweetly blinking from the highest attainable spot in a room. She was a little unkempt and quite capably defensive, but due to her size and innocent demeanor, remained a dainty darling.

Sylvester was the climber. He could spring from tree trunk to tree trunk like a squirrel. We found him in a parking lot, a large oozing wound in his leg, carelessly limping up to people hoping for a scrap of food. As he healed and we came to know him, we deduced that his fateful injury was the result of his own insouciant recklessness.

Coco, rescued from a house fire, her fur burned away and her owner lost. Terrified for months, she stayed in my parents' basement, isolated and unsocial, her coat a choppy brown mess. Over time she became one of my mother's most constant companions, and eventually—though it took years—her fur grew back, lustrous and black.

Cosmo, one-eyed, one-fanged and clawless, but definitely not defenseless and with an attitude that squelched any attempted intimidation by rival cats, arrived meowing loudly on my mother's back porch and then came to live at my house. He was very fond of me. So fond, in fact, that after our being away for a couple of weeks, he greeted me eagerly, if a little aggressively, jumped on my lap, backed up and marked me liberally as his.

And there was Smithy, the lithe stone-gray cat my husband and I heard crying from high in a fir tree on our morning walk by the river. The tree trunk was bare of branches for thirty feet above the ground. The cat clung, exhausted, to the very lowest branch. A city crew came with a cherry picker, and a gloved, goggled and heavily clothed burly man snatched him cautiously from the lowest branch. We gave him to my parents, and when my father was dying it was Smithy who lay curled in his arms till the end.

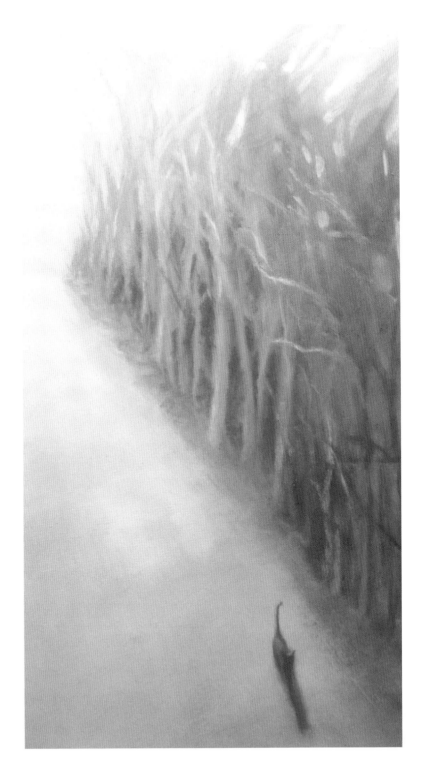

THESE CATS and others are gone now. A few of them have found their way into my artwork, but mostly the cats you see in my paintings are the ones that live with us today. They are our housemates and friends, the ones I know best.

Mister came to us as a kitten, four or five months old, meowing incessantly and appearing out of nowhere, as if he were one of those cats that fall with the rain. He sat wailing to the neighborhood from the intersection we look down upon from the top of the stone retaining wall that forms the foundation of our back garden. We couldn't ignore him. He grew to be a pulchritudinous tabby, an eighteen pounder, with a coat intricately and darkly marked like a butterfly wing. He is our watch cat, the one that growls when the garbage truck comes by and yowls into the black night as the raccoons slowly make their way past our windows on their nightly prowl. He's a talker with a large and varied vocabulary. He uses very distinctive phrasing when he's carrying, dangling from his mouth, a curling, writhing garden snake up the cobbled path beneath my studio windows. It's a song that I can hear before I can see him—part gurgle, part meow, part trill—and I always know what he's brought me. Mister is a slow-moving earthbound cat, which is probably why snakes comprise his entire hunting expertise, but with a snake in his mouth, he trots with excitement. He's a cat that looks you directly in the eye, unblinkingly. If you meet his stare he'll keep you locked in it until he gives an abrupt squawk, the signal that the necessity for that sort of thing is apparently over, and he turns and strolls away.

Indie, short for Indigo, arrived a day or two before our feisty calico Angie died of liver failure at the age of eighteen. He draped his black, languid and luxurious body over the top of the pigeon cage, which then sat on the back porch, looking as though he'd been there invisibly for a long, long time, and like the Cheshire Cat only just then made himself apparent. At first we didn't feed him, presuming he lived in the neighborhood and was only interested in Pidge, our adopted one-winged pigeon. He would disappear at night and then be back on top of the cage in the morning, his fluffy tail swinging slowly back and forth over the edge. We put up "found cat" signs, but no one called. Angie had left a vacancy and Indie moved in. Sylvester was still with us then and Indie, who was a youngster, imitated him like an apprentice circus performer, trying to climb trees and fences with equal ease, following him to all sorts of precarious places. He never became as agile as Sylvester, but he still paces the high wooden fence around our suburban lot like a tightrope walking sentry, a clear-cut cat-shape, always a pitch-black hole in the sky. He is the beautiful one with a warm, rust-smudged, coal-colored coat, soft and long, but never tangled; a

plush feathery tail and a ruff around his neck that grows thick in the winter. Although confidently combative with other cats, I've never borne a scratch from him. He's lithe but solid, loose-limbed, heavy and relaxed in your arms. The most gregarious of our cats, he easily strolls up to people and mews a plaintive request for admiration . . . or something.

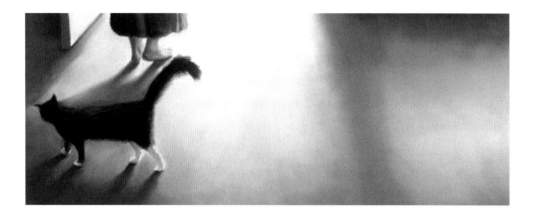

The reason for the presence of cats in my artwork has changed over time. In earlier work, they simply were there, hanging around, a part of the setting, adding a note of life in an otherwise unpopulated scene or a bit of companionship in a figurative piece. But the cat was not the subject. The cat did not represent an idea, did not masquerade as a person in anthropomorphic guise. It was a cat in the room.

I thought it was dangerous to portray cats. A picture of a cat could lead to the brink of a treacherous descent into sentimentalism. I couldn't resist the tantalizing brink, but I was careful. From a painter's point of view, a cat's animal beauty and elastic physicality along with the mystery of its motives and a domestic accessibility make the cat an aesthetically alluring subject, but I did not want to become a cat artist.

THE CATS I'd lived with, all house cats who ventured outside, were cozily distant with me. They slept with us, on our heads, slowly spreading till they filled an entire pillow or they securely pinned our legs with the weight increase they seemed to experience once in bed. They spent inclement days curled up in a chair or on a table, preferably a place covered with newspapers or important paperwork, or watched the robins flock around the ripe orange berries on the pyracantha outside the window, twitching and cackling from time to time, swishing their tails. But on fine days they roamed the garden, found a sunny spot in which to groom themselves, or vanished completely all day. They might show up at lunchtime for a snack, only to disappear again till it was nearly dark. They always came home and were affectionate and attendant, an important part of our lives. They brought us an essential joy and grounding that was especially welcome on harried days. I loved my cats, but a lot of the time I really didn't know what they were doing. I was busy and so, apparently, were they. I had always thought cats were serious creatures, too often lightly regarded in our self-absorbed and nature-dissociated culture, but it was when Cabbit materialized that I knew I had only begun to understand the hidden depths of a cat's nature.

IT CAME when we were remodeling our kitchen and had set up a "summer kitchen" on our back porch, complete with refrigerator, propane stove, prep table, and shelves for dishes and utensils, pots and pans. The grape vines that twined along the balustrade and up to the roof made a green filter against the hot summer sun, and their tendrils fingered through the shelves of provisions. We situated an old upholstered recliner facing out to the garden, with a standing lamp beside it. The porch became an extension of our house that held, in a simplified manner, almost all the conveniences and comforts that had been demolished inside. With our leafy garden at its steps it was idyllic and civilized.

Because of the construction dust and disorganization indoors, we spent a lot of time there and throughout the summer wondered why we needed an indoor kitchen at all, enjoying a life divided between days outdoors and the safety and comfort under our roof at night.

One day my husband Bob reported spotting a rabbit in the garden. "You know, a bunny rabbit, like the kind a kid would get at Easter" he said. For days, whenever outside, I scanned the flower beds and hedges, looking for this rabbit. I wasn't concerned about its diet, knowing there

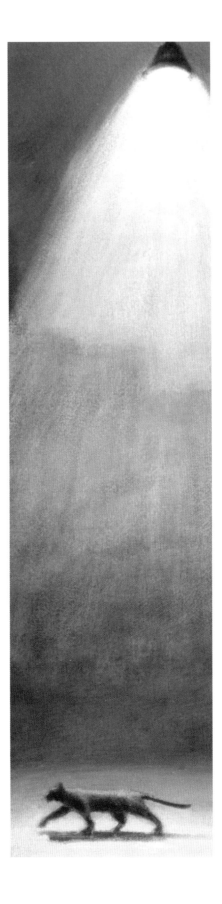

was plenty of leafy stuff available, but wondered how it was getting along with the cats. At this time we had three males—Mister, Indie and Cosmo. Bob kept startling the rabbit whenever he checked our nightly barbecue or carried groceries up to the porch. It would hide beneath a bush or behind a fence post, but its stumpy tail and long hind legs would bound away so fast he could never see it for more than a second or two. All he could tell, he said, was that it was black and white and maybe a "pygmy rabbit," it was so small. I, on the other hand, never saw it. This irked me, but in the midst of a major remodel, I didn't relish the idea of adding a rabbit hutch to the pigeon cage, so I pushed any concern to the back of my mind and hoped it was living well on the garden and making friends with the cats. Early one morning I opened the French doors to the "kitchen" and something sprang out of a frying pan. I caught a glimpse of fur and heard a patter through the honeysuckle that grows over the fence just beyond the edge of the porch. Ah-ha, the bunny! Finally.

A week or two later, arriving home on a windy autumn night, we walked up the path from the driveway through our back garden, and in the rain-dappled darkness I caught sight of a small black animal skittering over the edge of the stone retaining wall. I ran to the opening in the fence, looked down across the street and under the streetlamp I saw the little creature with its long shadow tear across the sparkling wet pavement, then dive into blackness under a neighbor's shrub. Funny, I thought, it and its shadow had very pointy ears, not long, rounded ears like a rabbit. I went inside the house and came back out with a dish of dry cat food and a bowl of water and set them on the back porch. Thus began the slow process of taming Cabbit (cat + rabbit=cabbit) and my initiation into the world of a feral feline.

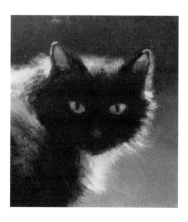

We became much more vigilant once we knew the little animal who had been living in our garden for the last couple of months was a kitten. We would stop to look through the window of the door before stepping outside and pause on the edge of the garden, motionless, carefully searching for a glimpse of the tiny cat.

Our sensory perceptions are extremely dull, hardly used in comparison to a wild animal's, and I'm sure that more often than not, when we didn't see the little cat, it was crouched and camouflaged watching our oblivious and heavy-footed movements. If we did spot it, it was only after it had seen us first, and therefore was on the run, the knob of its tail and the pink pads on the bottoms of its white back feet vanishing under the fence. The cat seemed to have the reflexes of a small bird, darting at the slightest provocation. Perhaps it felt vibrations in the earth through its paws. Or its ears, like sonar cups, turning this way and that, heard our hushed approach, and its whiskers sensed movement in the air. I imagined its heart beating so quickly that it hummed rather than pounded. Our speculations about its amazing awareness didn't really answer the riddle of how it could know when we were looking at it from a closed window. But it did know. Its head would turn slowly toward us; its gaze owlish, its body frozen. It would stare, black pupils enlarging, the surrounding golden-green iridescence disappearing, till finally its eyelids would drift closed, an alternative retreat to its usual frantic flight. In the darkness behind its lashes, we were no longer there, and that's what seemed to matter.

Winter arrived one morning with a surprise snowfall, and on that day we moved the refrigerator back inside. Mister, Indie and Cosmo also were spending most of their time indoors, only going out to make sure that the weather wasn't better than it had been the last time we'd opened the door. But our phantom kitten remained wild, making her own way in the outside world. Our cats never chased it off or fought with it. Sometimes, when the weather was fair, we would see Mister and the little one lying about together at the far end of the yard, a very large impassive tabby sprawled beside a very diminutive but by now presumably full-grown black and white cat, who playfully batted his head or abruptly and inexplicably leaped over his relaxed, prone body.

That winter we had unusually frequent snowfall and nights of freezing temperatures. I worried about our little cat. We kept food available on the porch and knew it came to eat by the tiny prints in the snow or the wet blotches, five little ovals for each paw, leading up to and away from the bowl. We reckoned it slept beneath the porch in the piles of drifted maple leaves that had collected there on windy autumn days. We hoped it was warm and snug.

Our pigeon cage, a later and larger version than the one occupying the back porch when Indie arrived, sits against the eight-foot trellis fence at the back of the garden. It's a rustic, not charming, screened structure about six feet wide and four feet deep with a discarded ordinary interior door for access and a shed roof that slants away toward the fence. Inside we've built little hutches and ledges for roosting, and beneath them we store a bale of straw for spreading around, which also gives the birds another elevated warm place to nest. Overhead is a network of boards and branches for perching. It was built to house two lucky pigeons: the aforementioned Pidge, and another disabled, once-homeless pigeon, Peep, along with their resulting brood of children who now form a regular flock. Because of the vulnerability of the two flightless birds, the cage has to be cat- and varmint-proof, but still allow the birds who could fly to come and go freely. We had no desire to keep wild birds caged, but if Pidge and Peep got loose, theirs would surely be a deadly escapade. The shed roof has a large front overhang and just beneath this is a landing platform, about six inches deep, in front of a three-inch high by two-foot wide opening in the screening. This portal is too small and its location too awkward for a cat to climb into. It is also too high for the grounded Pidge and Peep to reach. This works quite well, and even though Indie lies on the edge of the roof with his paws outstretched for oncoming pigeons, they swoop under the eave with ease, and Indie is left swiping at empty air. I feed the pigeons daily, check for eggs, preventing a population explosion, and change the water. During that cold winter I had to break the ice on their water dishes many times.

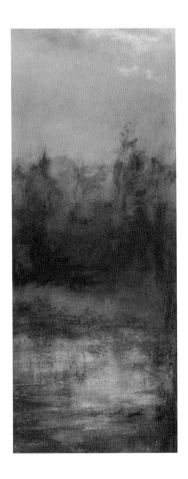

One very rainy day, dark and miserable—the kind of day when it's rained so much and the earth is so cold it no longer absorbs the drops, and water bounces up to make a gray layer of frothy muddy spatter all over the ground—I opened the door of the pigeon cage to see Cabbit snuggled down in the yellow straw, eyes wide and terrified. Unconcerned, several of the pigeons pecked at fallen grain and hopped up onto the bale of straw within inches of the little cat. Cabbit, trapped and tense like a hobo found squatting, didn't move but appeared to be dry, warm and encamped. I slowly backed out into the pouring rain, and closed the door.

Upset by my surprise entrance, the cat instantly leapt up onto the shelf, then to the narrow crosspieces suspended near the ceiling, nimbly making its way to the opening under the eave. Squeezing through the slot, it threw its hindquarters over the edge, gripped the landing platform with one forepaw, dangled for a moment while its back feet found the screen, let go of the platform, swung sideways catching the screen with its claws, then backed down as an acrobat might descend a rope. It was such a swift and effortless maneuver that it must have been practiced. How much time the cat spent with the pigeons we'll never know, but they were completely comfortable in each other's company, and after that, whenever the day was dark and the rain relentless, I always peeked around the door before opening it to see if our little black-and-white, bob-tailed kitty was nestled in the straw. And every once in a while it was.

FOR ALL its bursting and blooming, true spring emerges slowly. The early warm days tease us, then abruptly the temperature drops, a hailstorm flattens tender green shoots, or frost sneaks in to burn the buds and we are impatient, thinking spring will never stay. Taming the little cat was like this—slow, vacillating between flowering and freezing.

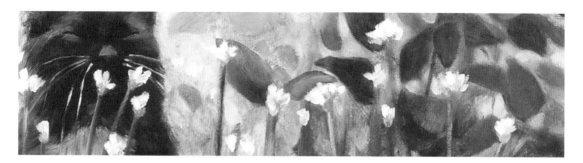

Sometimes as I pulled the car into our back drive, the cat sat sunning itself on the south-facing rock wall just a few feet from the driver's side window. After a moment or two of big-eyed shock, it wouldn't run off, but instead circumspectly shut its eyes and allowed me to slowly get out of the car and move away. This was progress.

It was very self-sufficient and played in the garden on its own. It sprang at imaginary prey, hopped and tumbled, twirled twigs in the air with its paws. At these times, alone, it seemed carefree and unafraid. We even found pilfered cat toys, not belonging to our cats, in the flower beds.

On warmish days we would leave the porch doors open to enjoy the fresh air even if it was brisk. The top of the staircase in our house which leads down to our work area is within a few feet of the porch doors. Occasionally, as we came upstairs, our heads just clearing the floor, we would spy the little cat leaning, stretched up on its toes, peering inside from the threshold. But we never got closer than that, and as far as we know it never came inside.

It was as wild as a blue jay, and although an accepted member of the backyard wildlife at our house, not nearly as chummy as a squirrel, so we were never able to determine its sex. Nature soon helped us out and almost precisely on cue, a day or two from the spring equinox, she went into heat. Spring had arrived, but now we had a big problem. Our blasé, neutered males weren't the least bit interested, but we soon found out which cats in the neighborhood had thus far avoided any spay-and-neuter program. One, a young fleet-footed tabby, quickly and loudly impregnated Cabbit below my framing room window. How were we going to have her spayed now? We had blithely hoped that if it were female, we could tame her before her sex became an attribute with consequences. The next day we borrowed a live trap from the local animal aid society and baited it with canned cat food, something smelly and irresistible, set it on the back porch in place of her food dishes, and waited. It wasn't long before she came sniffing. Bob and I watched from the shadows in the living room behind the closed porch door window as she tiptoed into the trap. Nonchalantly she ate the dish of food and backed out uneventfully. Smacking her lips she trotted off. The mechanism relied on the weight of the animal stepping onto it to trip the trap. Apparently she was too light.

The next day Bob painstakingly greased up the mechanism, set it with the lightest touch possible and we tried again. After her most extravagant meal ever on the previous day, Cabbit was eager and unafraid to enter the trap. She stepped on the lever in front of the dish and the door dropped shut. Startled but wary she slowly backed up, touched her rump to the closed door, and exploded. I'd never seen an animal thrash so violently against an immovable object. She yowled and screamed and repeatedly rammed with all her feral force into the wire walls. Hoping that darkness would calm her, we threw a towel over the trap. She instantly became silent and still.

Only some vets will handle feral cats, but luckily I had found one close by and made arrangements. It's an on-call situation, since one

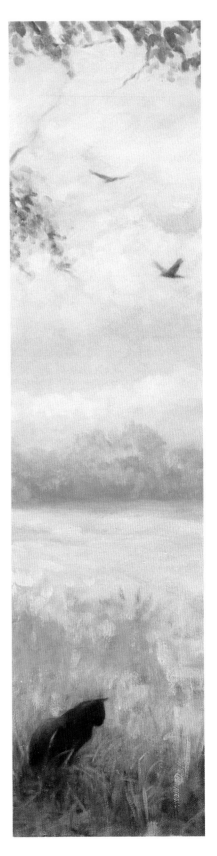

never knows when the cat will show up, and a trapped cat is not likely to be patient. We were ready to go and we transported her in the towel-wrapped cage, arriving at the vet within minutes of her capture. She never moved or made a sound and I tried not to think about how scared she must be. When we picked her up that evening, they had docked her right ear to identify her as a feral cat, given vaccinations and removed an embryonic litter of kittens from her tiny body. She was particularly small, perhaps four pounds at this time and would certainly have died bearing them. We were told to keep her in for the night if possible and let her go the next day. I was not about to let this little cat go out into the wild world immediately after major surgery. I had made our spare bedroom ready for her—food, bedding, a litter box—and planned to keep her there for the week, then release her through the house to the open porch door with the thought that if she found her way out, made it unharmed, she might be less wary of the indoors. I was so clever. Of course she came home in the trap, since we couldn't handle her, and she was still drugged and groggy when we set the trap down in the room and opened its door. Wobbly, eyes unfocused, she staggered out of the cage, took a slack-jawed look at Bob and me hovering over her, then went berserk, smashing into furniture, her legs collapsing as she tried to get away from us in her stuporous state. Instinctively, but stupidly, I reached out to her. Terrified by my nearness she clambered up the side of the bed and from there threw herself toward a rectangle of light, slamming herself against the only window in the room, clumsily clawed up the interior screen, then fell off backwards only to awkwardly gather herself up and try again. At this point Bob grabbed my arm, pulled me out of the room, and closed the door.

We didn't see her all week; she was always hidden when I went in to feed her. The first couple of days I shone a flashlight under the bed, caught her green-gold eyes in the beam, and was relieved that she wasn't dead or perceptibly sick, but from then on I tried not to frighten her unnecessarily. She tidily used the cat box, and her appetite was good. But I never saw her. Our bedroom was next door, and in the night we would hear her scrambling around, presumably playing with the few toys I'd left her. By the end of the week, she cried, mewing over and over.

The day arrived to release her. That morning I was passing through the garden and happened to glance up at the window of the room she was in, a story and a half above ground level. Our house is old and its wooden windows are paned and screened on the inside with metal roll-down contraptions. One of the lower panes in this particular window was broken, a small jagged hole in the center, which we had securely duct-taped over, inside and out.

That day the duct tape was flapping loose, the hole in the glass exposed. I ran up to the room to investigate, and sure enough she had clawed back the aluminum screening, squeezed herself into the two inch space between the screen and the window, and—like a prisoner digging a tunnel with a spoon—she'd doggedly and effectively peeled back the duct tape on both sides of the glass to finally push her way out through the sharp-edged hole. Tufts of fur clung to the pointy shards.

The pictures which ran through my mind in that moment were not pretty—stitches torn out of her little belly, bloody paws, shredded ears, followed by a scene of slow death by infection and starvation under a bush. Bob shook his head at me. Well, she'll never come back now, his eyes said. We looked for her, but knew we'd never find her. She had never let us come close; I had destroyed her. I was devastated.

I filled the bowl of food on the back porch and hoped. Late that afternoon, as though nothing had happened, there she was, tucked up to her dish, unperturbed, hungry and apparently undamaged.

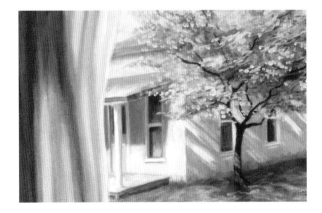

HER WILDNESS was unfathomable given her attachment to our quarter-acre suburban enclave. But wild she was. Although now she was more visible in the garden—sometimes curling up on a garden chair cushion, or trotting through in full sight, focused on some unknown errand—she remained on the edge of our lives. I started leaving treats for her on a garden table, near the pigeon cage, setting down just a couple and then retreating to the house. I knew she would be watching from a distance, and as soon as I was safely behind a door she'd appear, jump onto the table and comfortably munch the treats, glancing in my direction once or twice. She never expected more and just hopped down, trotting off as if returning to work.

In the height of summer our tall maple trees canopy the back yard with a cool green light, and vines—in full leaf and flower along the encircling fences—effectively shield our view of the surrounding neighborhood. Now that we had a kitchen door, added in the remodel the year before, as well as the porch doors opening wide onto the garden during the day, the division between indoors and out was becoming increasingly vague and variable. We always kept our cats inside after dark, but in the summer it's especially pleasant to let the chill dusky air in to cool the house overnight. In the middle of one of these nights, Mister, with a frustrated nocturnal desire to rid the garden of prowlers, pushed out and in the process, folded, with his ample body, the flimsy screens of my open ground-level studio windows. This incident effectively made the breached windows unobstructed entrances and exits during the day. I could rest my elbows on the sill in the open air and watch a robin within inches of my face pull a pink, stretchy worm from the earth in the bed of epimedium and oxalis that grow at eye level or reach out to stroke Mister, drowsing as he often did in the dusty, sun-warmed plants. My studio door, at the very far end of the house, also often stood open. Our world was made of a series of openings and paths leading in and through, up and down and out. Mister, Indie and Cosmo could come and go as they pleased, and Bob and I could work without being interrupted by whining demands to let them out or in.

I brought Cabbit's food in from the porch so that, in order to eat, she had to have courage and come inside. Our cats didn't mind sharing their dishes with her, and after a few weeks Bob and I could even be in the kitchen while she ate. But if we made the slightest movement, she fled, escaping out one of the doorways. Over time, as the summer settled in, I moved in on her, perhaps creeping six inches every other day, diminishing the tolerable distance between us. One day I found myself close enough to reach down and touch her! My fingers had barely brushed her back when she turned, looked directly up into my eyes, and then ran. I had never touched her before. And except for the anesthetized handling she'd received at the vet, I don't believe she'd ever been touched by another human. I didn't abuse this miraculous development and only reached to touch her every once in a while, and only in the kitchen where she came to eat. She would still run away, but each time a little less far, and then would turn to look at me. If I backed away she'd return to her dish.

HER COMFORT with this contact grew and eventually she endured touches that turned into strokes, but still only briefly. This went on for many weeks. At times I thought this was as close as we'd ever get to her. Then one morning, no longer able to resist, I reached down, snatched her up to my chin with both hands, and held her against my throat. She didn't struggle. I felt her heart beat, my pulse press against her ribcage. The beating became purring. I held her only a minute, probably less. She was so small, almost weightless like a bird. She began to squirm. I immediately set her down, paws to the floor, and she leapt out the kitchen door into the sunlight.

That was just over three years ago. Between then and now Cabbit and I have shared a very gradual and romantic indoctrination into each other's nature. A couple of months after we felt each other's heartbeat I started painting cats as cats, not just including them in a scene or depicting them as companions to humans, but as beings, inhabiting their own world. It is a world enticingly evident to me, but one I still don't completely know or understand and undoubtedly never will. Being an artist and not a naturalist or animal behaviorist, I know this venture has been highly subjective and based exclusively on my experience of cats with whom I have lived.

It is also defined by paint and by my concept of a good painting, and the limitations inherent in those two things. But any understanding or perceptive truth contained in these paintings has come directly from a deepened connection with my cats, which in turn has come from knowing Cabbit. For me, this has been a lesson in how a human being's life can be enlarged by a relationship with a particular animal. And not so much by our similarities, those human characteristics we try to comfort ourselves with by recognizing them in other species, but by observing aspects of an animal's awareness and unique solutions to their own situation in the world, behavior that ultimately illuminates a part of ourselves that we have been unable to see any other way.

BY THAT autumn, more than a year after we first spotted her, she was spending her nights inside. A long ritual preceded the daily homecoming. I would begin calling at dusk. I'd call and call her name and various endearments, sometimes very loudly. Eventually, I'd hear a squeak in the distance. It might have been confused with an evening bird call, but not by me. Then longer cries, dopplerized as she neared, and I would spot her across the street, darting from shrub to shrub like a mouse scurrying from safe hole to safe hole, all the while alternating her answering meows with my beckoning calls, till she slipped through the door I held open for her.

Handling her became easier, but she never allowed anyone but me to do so. She made a habit of rubbing her whiskered face against mine, her paws encircling my cheeks, gently holding tight. Her affection for me was so personal, our connection clearly intimate and intense. Bob thought she related to me like a littermate. I certainly had never been treated like this before by another cat. It was like being inducted into a strange and slightly savage tribe, and like a novitiate, I longed to learn the secrets that would be revealed to me once I completed this rite of passage. Occasionally I would act in a way, obliviously, that turned her from purring contented furry animal in my arms to small, spitting, clawing, killer. My size and my species neither threatened nor tempered her. Eventually I learned her cues and now can usually avoid the slashing and shredding, yet these, along with the nestling and the licking, seem important. Although in communion and tender with me most of the time, she will, when I behave in some unacceptable way, still face me in a tall fighting posture and lunge, chest out, ready to do battle. She won't do this with anyone but Mister and me. Perhaps in a self-delusion, I think I'm part of her wild family as well as her domesticated one. Maybe even the link. If she ever stops leaving red, welted scratches on my hands I'll fear I've lost my special status.

Our mutual education has progressed steadily but incrementally. We both have learned the meaning of our nuanced touches, but she is more sensitive than I on this subject and has learned much more. Major breakthroughs, like sitting on my lap or going down the dark staircase to our work area, have happened suddenly, without preamble. After months of only feeling comfortable sitting on the back of my chair, placing her paws on my shoulder, or staring from the top of the staircase gauging the possible dangers out of sight below, she decided to cross these new frontiers and never looked back. I was fascinated and nonplussed by her ability to cumulatively learn an ever-increasing number of lessons: how best to behave, how to conquer her fear, how to earn the trust of pigeons, how to love me, how to adore Mister, the only other creature she seemed to have a relationship with, even though his response to her is lukewarm at best; but not to love Indie or Bob. I had never witnessed an animal making so many choices, new ones all the time, over years. She appeared to become tame, a word that implies we forced something on her, but I suspect she just adapted in a sensible way to the situation. She desired to live here, with us, and used the tools of her nature to make that work. All the choices were hers.

CABBIT NOW sleeps in bed with us, eats only commercial cat food, spends most of her time indoors, and aside from a skittishness with strangers, could no longer be described as feral. Memories of her youth still lead her to the warm, dry straw on the floor of the pigeon cage when she's surprised by a pelting rain shower. When one of these hard rains comes I stand on the porch, call her, and invariably she's there waiting out the storm with the roosting pigeons. Her exit route, and presumably entrance as well, is exactly the same as when she was on her own. When she hits the ground she dashes to the porch, then to the warmth inside. But even now, if I leave Cabbit out past dark, I'll find her crouched down in the ivy, focused and alert, staring into the dark green tangle. I near her and quietly say her name. She'll ignore me, absorbed by the sounds of the mouse or the snake or the beetle, or the phantom prey that my ears can't detect. If I persist, she will acknowledge me, slowly turning her eyes, large and calm, but with a blankness that tells me she's unreceptive. Her eyes then slowly close and she is wild once again in the darkness behind her eyelids.

The cats spend their days, going in and going out, bridging their wild and domestic lives. On some days they exhibit greater indecision in this matter than on others and I watch, reflecting on my own restlessness. For people the choice between wildness and civilization is a defining decision. It is one or the other. There is much in the natural world with which we are uncomfortable and ill-equipped to manage. And we have spent thousands of years purposefully constructing a human civilization that provides for our unique attributes and shortcomings. But cats, during those same thousands of years, have lived both ways. We are fortunate to have them as companionable informants about the untamed, the wild, as they share this with us. Our relationship is symbiotic and naturally essential.

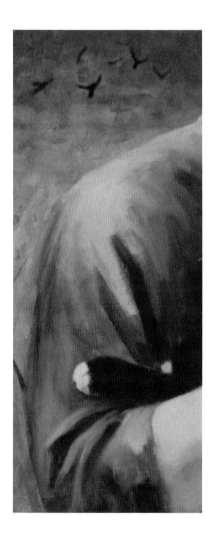

I AM no longer afraid to paint cats. They are fascinating and beautiful, painterly in character, varied in color and mutable in form. And my artwork is altered and expanded by my deepening understanding of these beguiling creatures. It is why I paint—to explore my world, to learn more, to understand what's around me. Cats live in two worlds, one with us and the other without, in nature. I aspire to the balance I observe in their lives. I wish I could be more like a cat and walk from independence into familiarity, from freedom to contentment, with the same soft-footed ease, understanding fully the threshold between them. I wish I had the innate qualities cats have that allow them apparently no inner conflict with this duality, an unconfused comprehension of the natural combination of contrary states of being within them. Do they consciously pursue this? Did Cabbit need a shelter and companionship despite her extraordinary competence in the wild? Do cats living inside long for the sky, feel incomplete without it? What more could I bring to my work, if I could be like a cat? The place inside them where the wild and the tame are unified must contain the essence of Cat, the very magic cats are credited with. It's an essence of being I want to learn from, and perhaps by painting them, describing their lives with a brush and chalk, I will extract some other understanding of how to live in the world.

Painting cats is a complicated business.

THE PAINTINGS

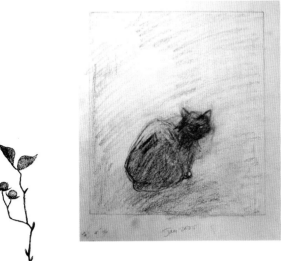

"Cat on a Moonlit Night" oil on wood 16" x 18" 2005

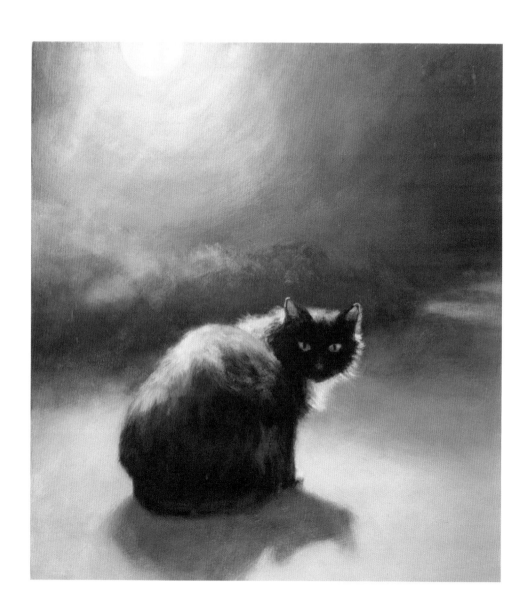

Light is always an important element in my work. And cats too seem to seek light, be it the sun, a window, a fireplace or the warm emanation of a lightbulb. My cats like to sprawl on my desk beneath the lampshade bathing in the incandescent heat. I love lamplight too, the enclosure and intimacy of it. The rest of the world disappears outside the edge where light thins into darkness.

"SEEKING WARMTH ON A MOONLIT NIGHT" PASTEL 14 1/2" x 22" 1999

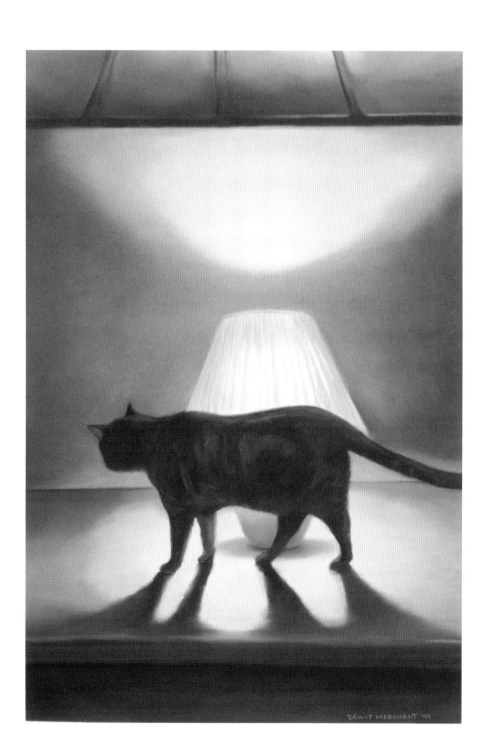

"INDECISION" OIL ON WOOD 18" X 18" 2006

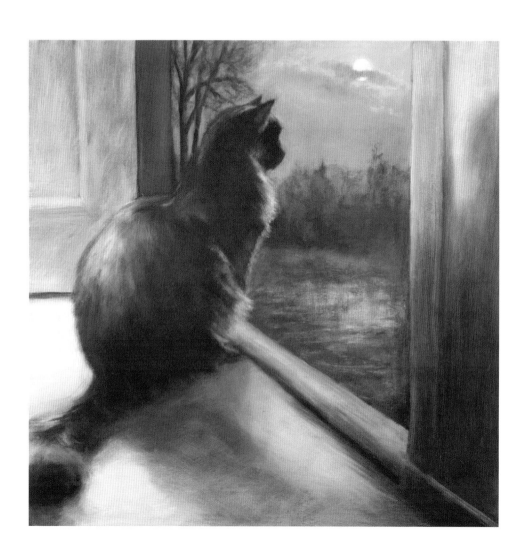

We live in a red house. The back of it faces west and we watch the sunset from our back porch and kitchen door. Evening is a seductive time for our cats and it's difficult to lure them in for the night. The daytime creatures are settling down, the nocturnal ones beginning to stir.

"GUARDIANS" OIL ON WOOD 24" X 30" 2008

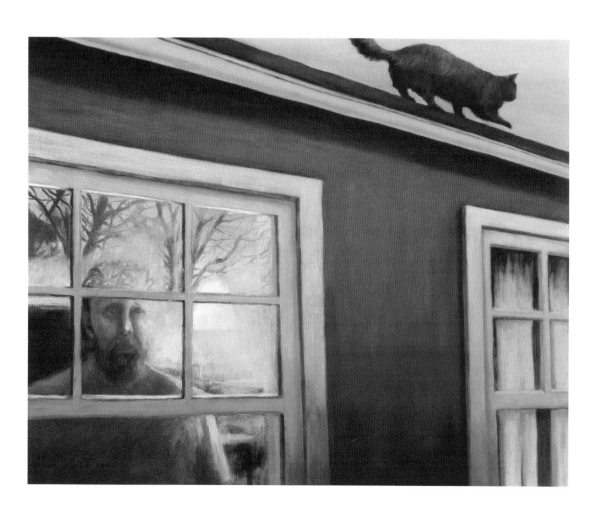

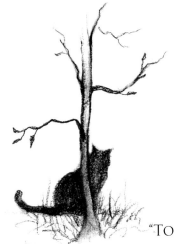

"To Blush Unseen" PASTEL 23" x 26" 2004

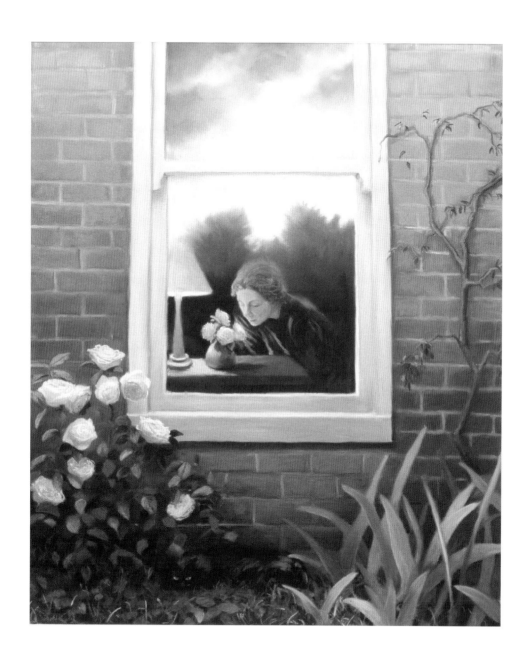

"THE GARDENERS" PASTEL 18" X 31" 2004

A combination of light, hour, a juxtaposition of memory with certain concrete elements can convey the very air that surrounds us at a specific moment. In this case although it is nighttime, and could seem cold, the roses, the screen door cracked open, the cat listening to nightsounds behind it, all help me to imagine the velvety breath of a warm summer night.

"SUMMER NIGHTS" PASTEL 22" X 27 1/2" 2001

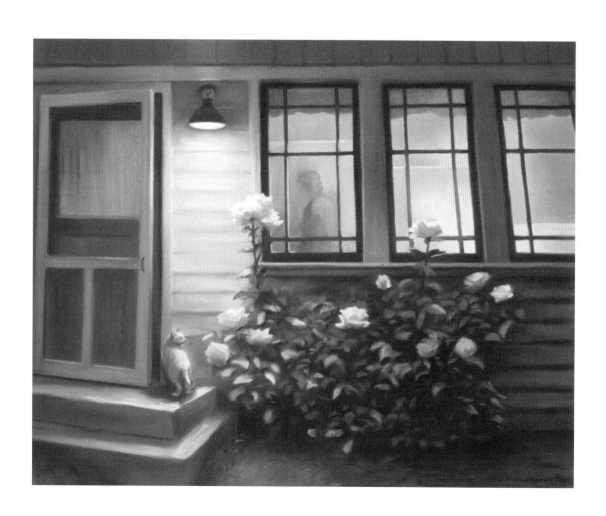

Our kitchen and dining area are in the same room, and during the kitchen remodel this nook was added to the east end. The sun shines through these windows in the morning and outside them is a huge, old cedar tree where the raccoons live. As the sun rises the cats like to watch them return home, as they climb the lower branches in slow, deliberate motion, until disappearing into the still dark reaches of trunk and bough.

"SATURDAY MORNING" PASTEL 21" X 31" 2004

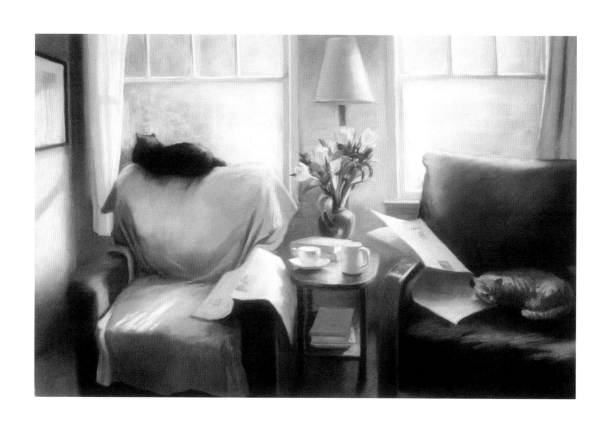

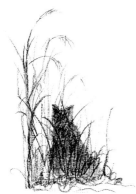

"THE EVENING PAPER" PASTEL 16" X 24" 2006

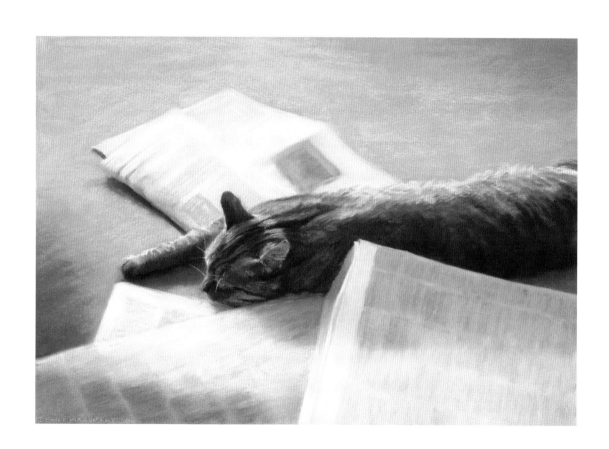

"CAT IN A BAG" OIL ON WOOD 20" X 38" 2005

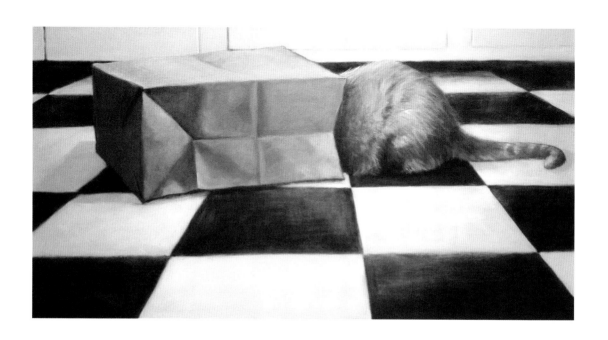

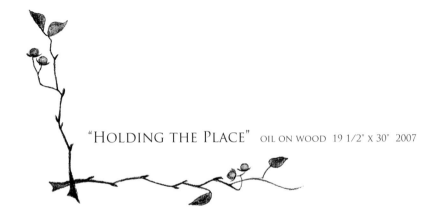

"Holding the Place" oil on wood 19 1/2" x 30" 2007

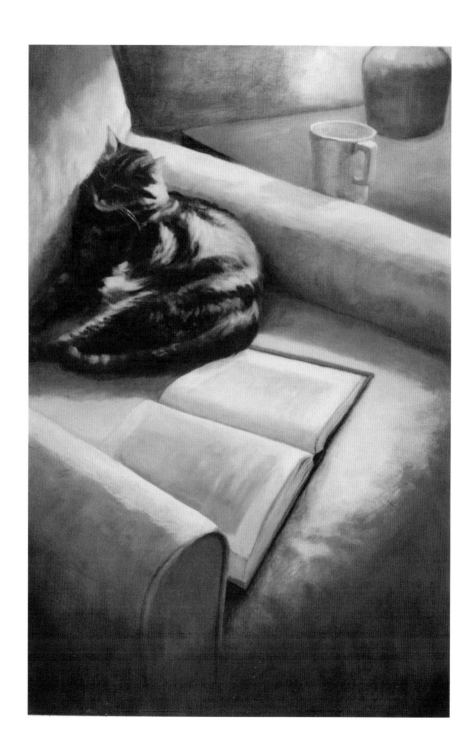

"TARRAGON" PASTEL 22" X 28" 1999

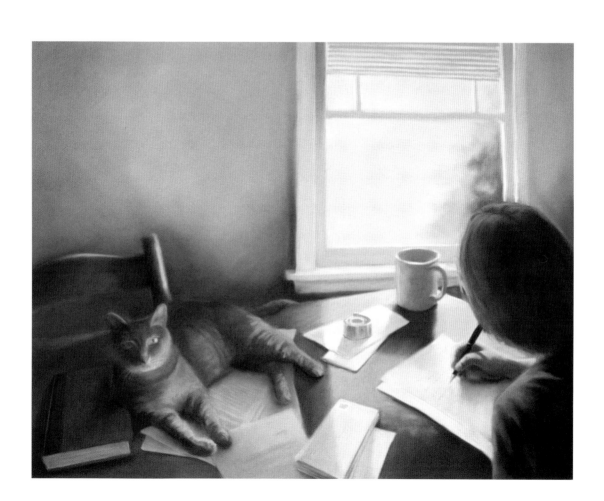

"Watching the Postman" PASTEL 16 1/2" X 23 1/2" 2000

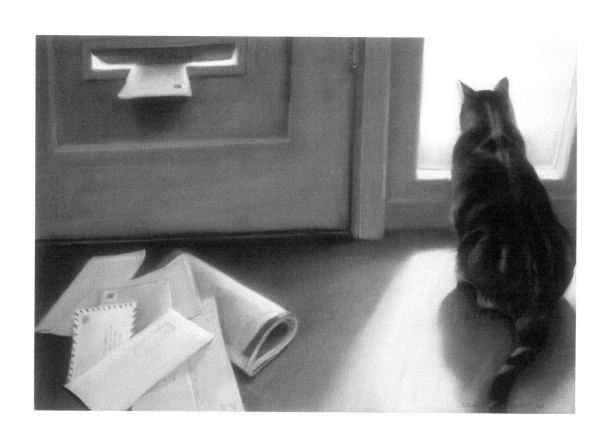

"Shadows" OIL ON CANVAS 28" x 32" 2004

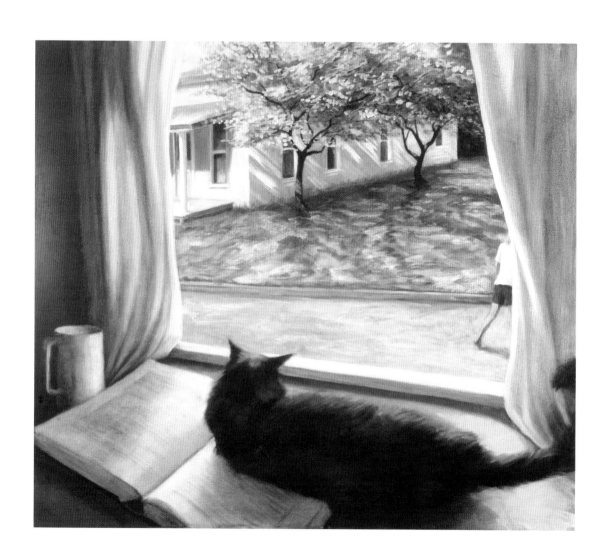

I have watched this for years from my studio windows, from the back porch and from our kitchen. This recurring scene, performed in all seasons, at the beginning and close of the day is forever etched in my mind. I had to sketch it, the silhouette, the strong lines, the narrative pose. The sketch includes the branches which overhang the fence, and a bird, likely harassing the cat, but finally the painting focused on the dark and the light and a cat, Indie, poised in between.

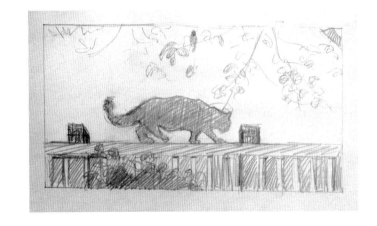

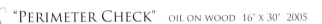

"PERIMETER CHECK" OIL ON WOOD 16" x 30" 2005

54

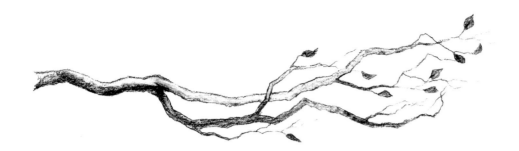

"HUNTERS" OIL ON WOOD 24" X 30" 2007

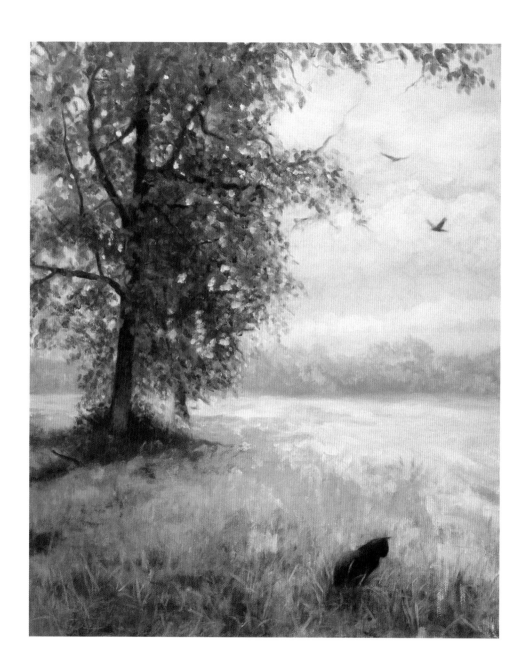

"EARTHLINESS" OIL ON WOOD 24" X 30" 2005

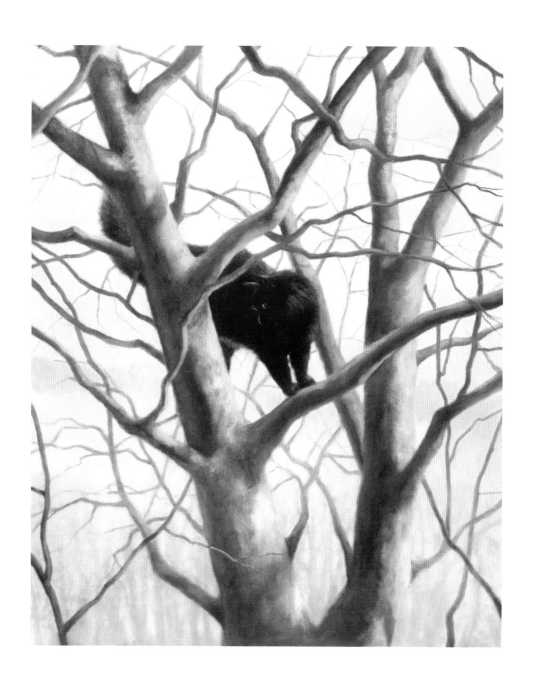

"NOCTURNAL MISSION" OIL ON CANVAS 20" X 30" 2001

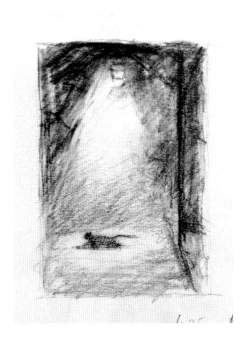

It's almost as if I was born with this vision in my memory. We've all seen it. The cat, stealthy and gliding, passing under a vaporous streetlamp or porch light, then disappearing into darkness. It's a lonely, ephemeral sight, that never lasts long enough to study. So, it stays in one's mind instead.

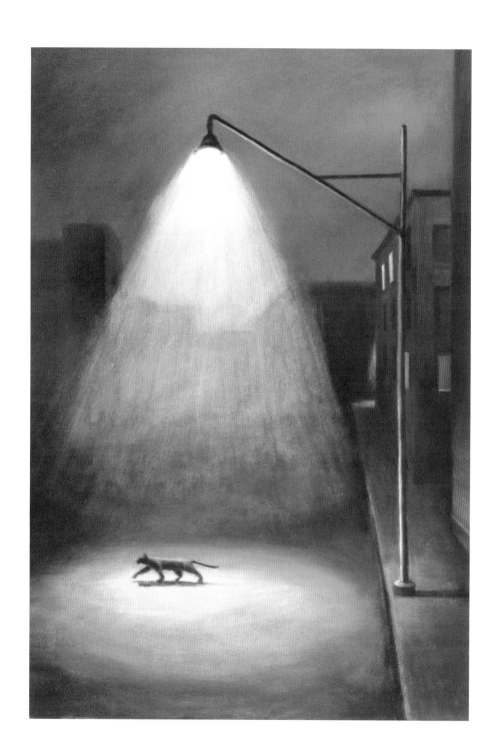

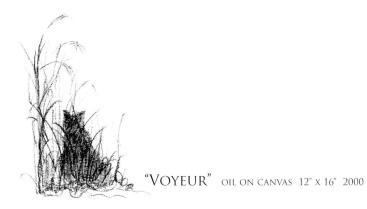

"VOYEUR" OIL ON CANVAS 12" X 16" 2000

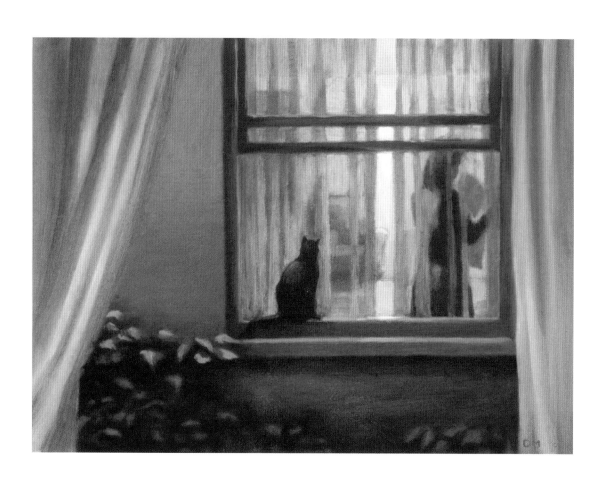

"INSTRUMENTS OF MYSTERY" PASTEL 22" X 31" 1998

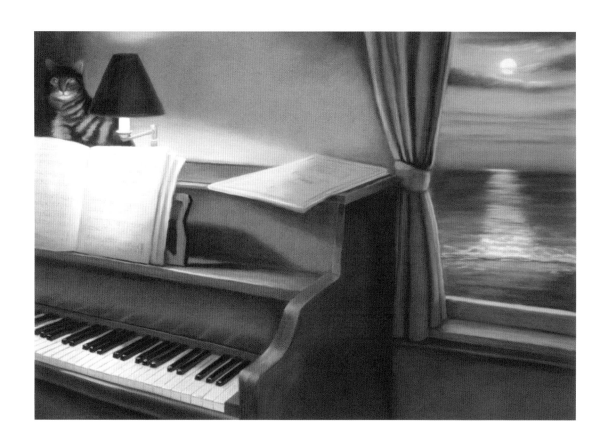

"CAT ON A RAINY AFTERNOON" OIL ON WOOD 16" x 16" 2004

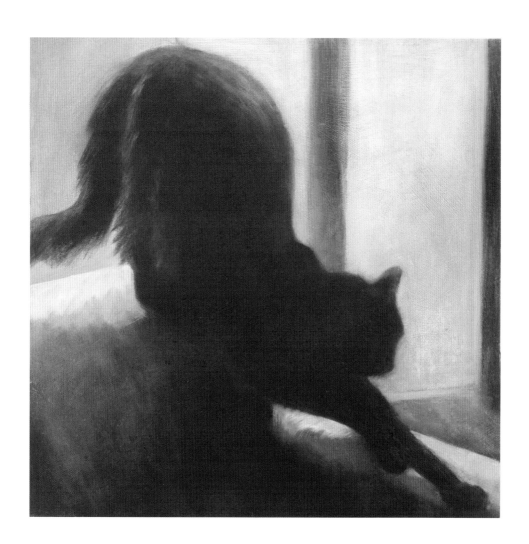

Cosmo died just about the time Cabbit came to live indoors. He'd seen lots of adversity in his life and was a most stoic cancer patient, making his painful decline all the more heartbreaking. Of all the cats he dominated the bedroom, ready to defend this territory and I like to remember him this way, watching over me.

"THE FAMILIAR" PASTEL 18" x 20 1/2" 2005

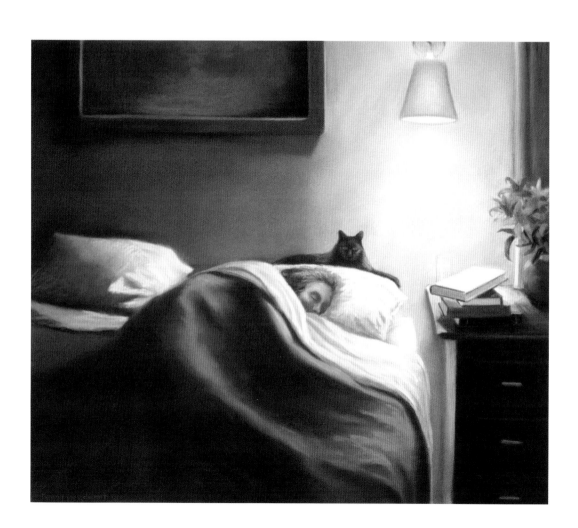

"SUNSPOT" OIL ON WOOD 18" X 24" 2007

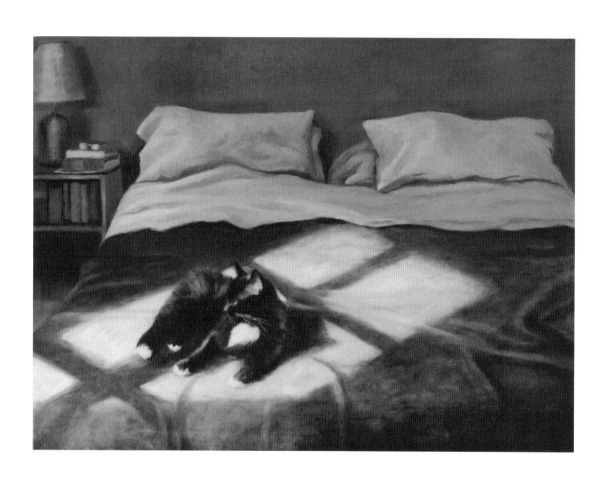

I have made many paintings and drawings about books, about the pursuit of knowledge, about our human need to learn and explore. Contemplating these subjects inevitably leads me to compare this human journey with the relentless and incomprehensible aspects of Nature. This piece is an obvious ode to these preoccupations.

"WISDOM AND WILDNESS" PASTEL 20" x 30" 2006

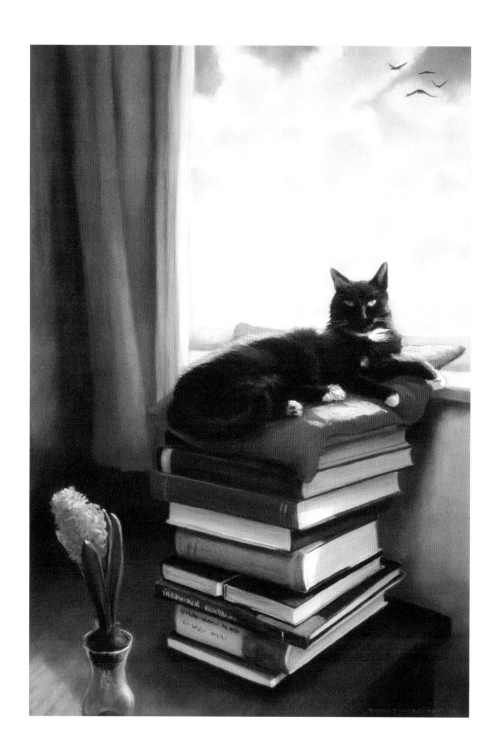

"RAIN" PASTEL 18" X 22 1/2" 2006

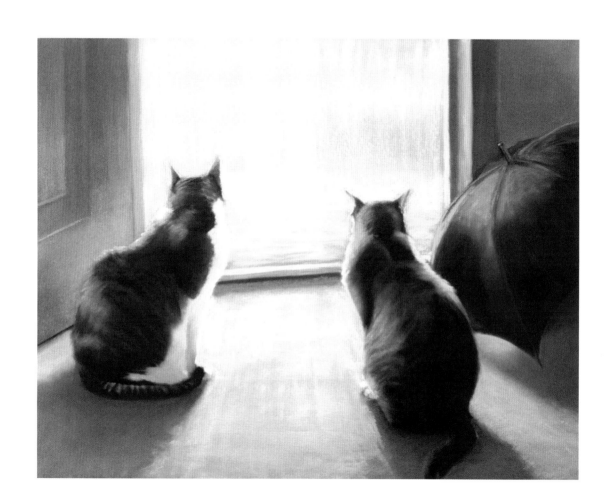

"Looking for the Door into Summer" OIL ON WOOD 16" X 24" 2005

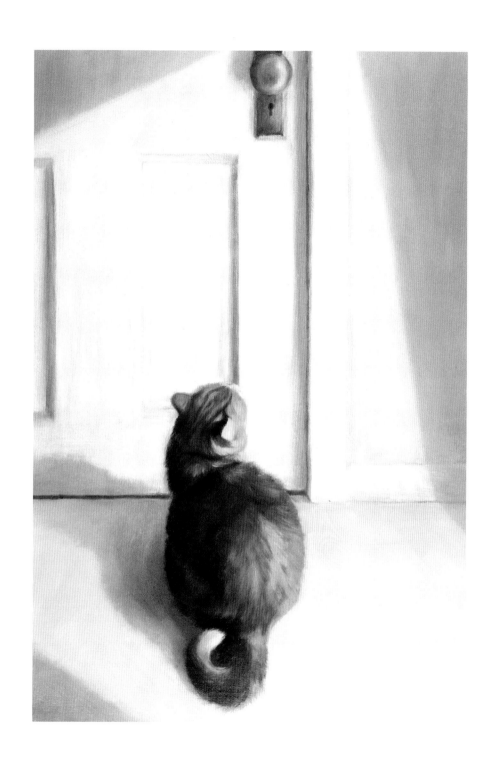

The shape of a cat is amazing. A cat's spine is so flexible that it looks at ease no matter how contorted or curled or bent or stretched it makes its body. A cat's ears and tail have a vocabulary of movement all their own and after spending much time with a cat you'll learn some of the language, like a foreigner with a phrase book. Some of the signals seem to be the common language between cats, some are peculiar to an individual. In the same way a person's laugh could be a snort or a cackle, a combination of ear twitches, tail swishes and spine twists can express an attitude, a character. I've done a number of paintings in which the shape of the cat is really the subject. It tells the story. This was one of my first.

"CAT ON A RAINY NIGHT" OIL ON WOOD 16" X 18" 2004

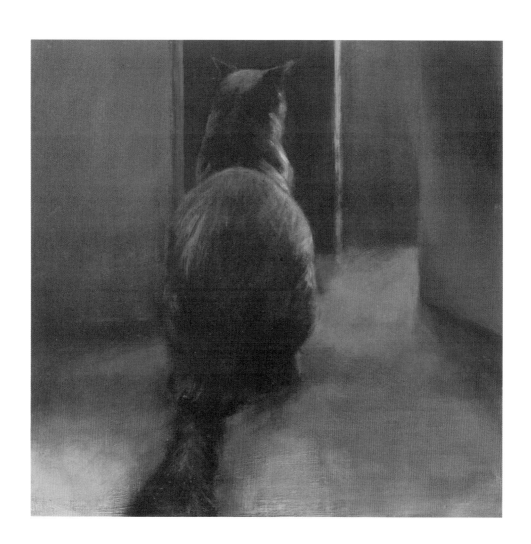

"The Highest Room in the House"
PASTEL 18" x 24" 2005

I have an office above my studio. The sole window in it faces south, and in the winter the cats take turns sleeping against the cold panes in the sunlight. Being an attic space it's also one of the warmest rooms, winter or summer. A perfect place for cats and for me.

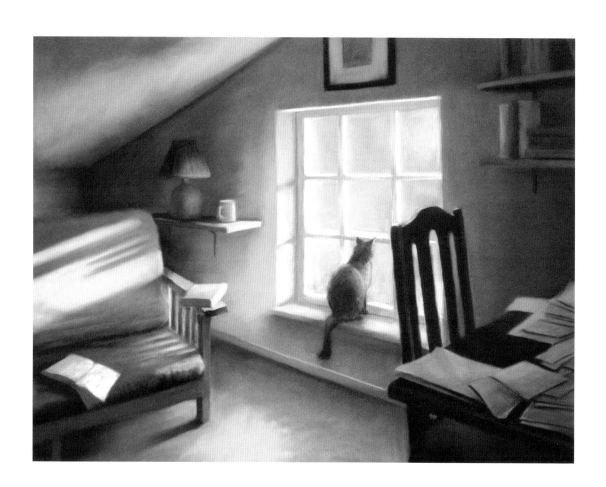

If we pay attention, we live in a world of metaphors. They are everywhere, giving color and meaning to our everyday lives. We've done many remodeling projects in the twenty-two years we've lived in our house. Our cats have lived through them also. Their ability to adapt and take part in the transformations in their cat-like way has often given us a new perspective and illuminated otherwise gloomy and tiresome predicaments.

"SEEING THE BIG PICTURE" OIL ON WOOD 22" x 34" 2007

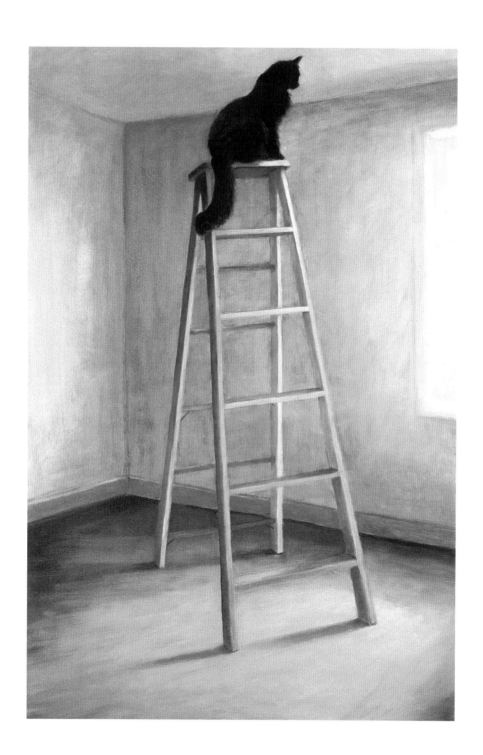

"A Cat's World" PASTEL 18" X 24" 2005

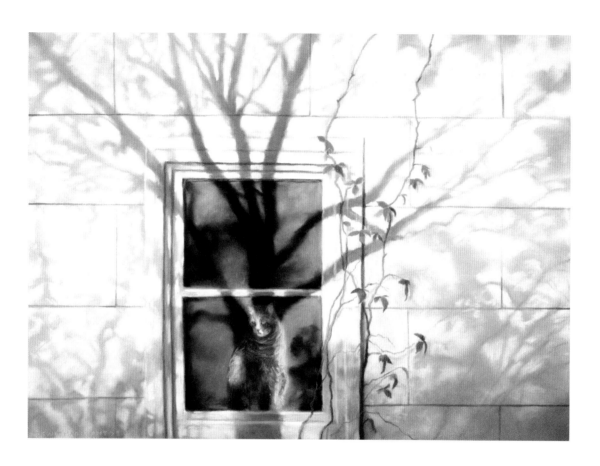

"BETWEEN WORLDS" OIL ON WOOD 21" x 27" 2007

Like a circle of lamplight the space between a pane of glass and a closed curtain delineates a warm hidden refuge that is separated from the world around it. I think cats seek out these places. A safe wedge from which to observe, alone, within permeable boundaries. The glass is transparent but impenetrable, the curtain translucent and flimsy, yet perceptively solid as a wall. We've watched the cats with noses pressed against the glass staring at birds who, just a few inches away, are completely unaware of the cat behind the bright reflections in the glass, while the cat is completely unaware that we can see his outline through the backlit curtain. It is a place of shifting materiality, light and space, where in this case, Mister feels completely comfortable.

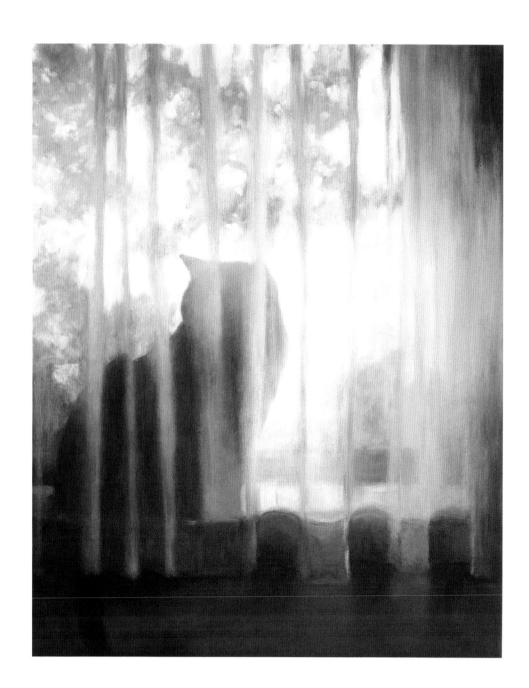

"THE FIRST WARM EVENING" PASTEL 17" X 30" 2002

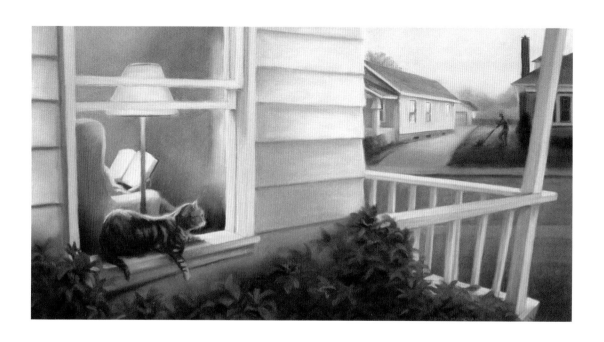

My fascination with light has led to an appreciation
of shadow. The color, the shape, the attachment to its maker.
If cats' shapes are extraordinary, their shadows are darkened
exaggerations of their changeability. My attention is arrested
when I see cats in sunlight or lamplight. It's natural that
their shadows follow them into my work.

"CAT ON A SUNNY MORNING" OIL ON WOOD 16" X 18" 2005

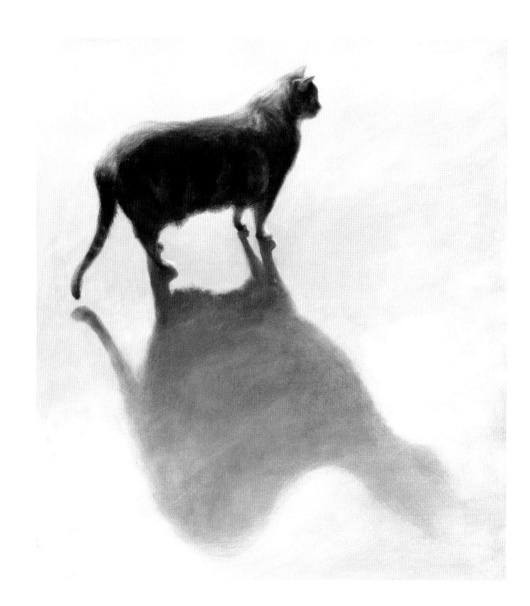

I've planted a lot of catmint in my garden. It's scattered about in several areas. Under the Dawn rose; in the lily bed, which has long since been without lilies; and on either side of a broken marble slab on which rests a pseudo-Victorian concrete bench. This plant doesn't grow robustly in our shady back yard, but rather as though it just fainted, limp, spreading out gasping for light, its lavender blue flowers getting crushed as they pass out onto the walkways and are trampled. It has a very musty, herby scent that the cats love. It's not quite as intoxicating as catnip, but the cats always find the first shoots in spring and nibble them hungrily. In full summer they just plant themselves over the entire shrubby mass of leaves and breathe in its aroma.

"CATMINT" OIL ON WOOD 20" X 22" 2005

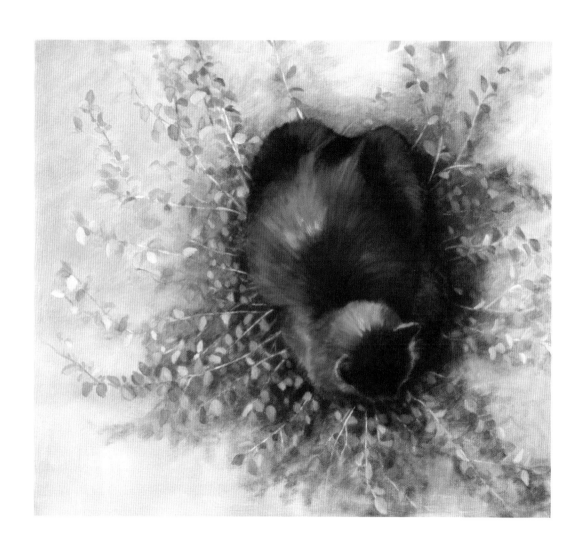

"The Once-feral Cat" oil on wood 16" x 16" 2005

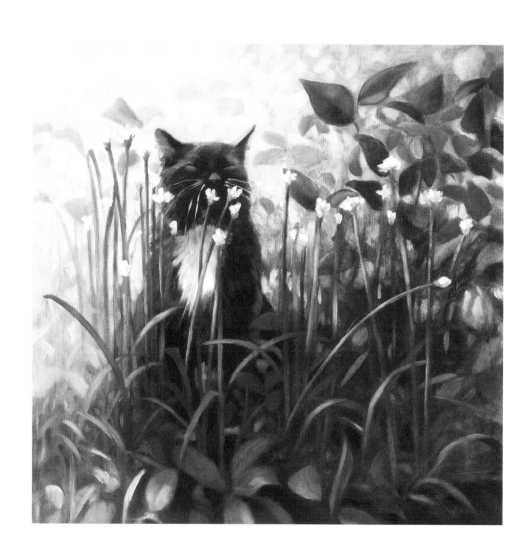

"AT THE BACK DOOR" PASTEL 18" X 24" 2004

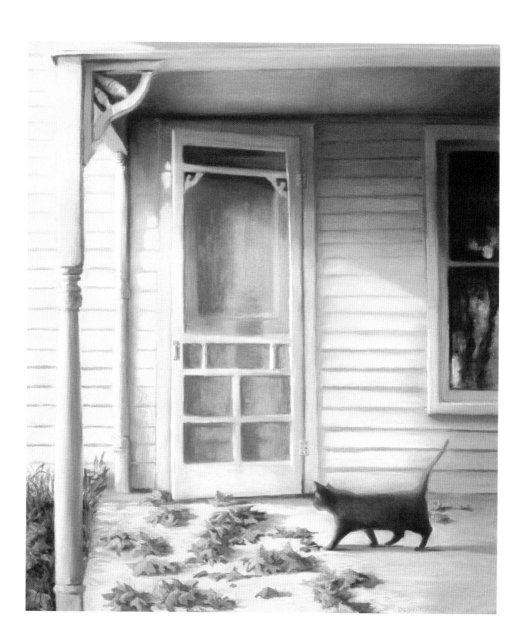

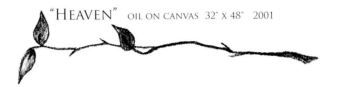

"HEAVEN" OIL ON CANVAS 32" X 48" 2001

Not long after my father died I had a dream that turned into this pencil sketch, then into a small pastel study and finally the oil painting to the right. I think I remember the dream, but it could be that by now the painting has replaced it. It isn't often that we can bring a dream into the real world with us. Our minds can contain so many dimensions at once while our bodies live in three. But I do know that in both my dreams and my reality, cats are there.

"SELF-PORTRAIT WITH CABBIT"

OIL ON WOOD 24" X 30" 2008

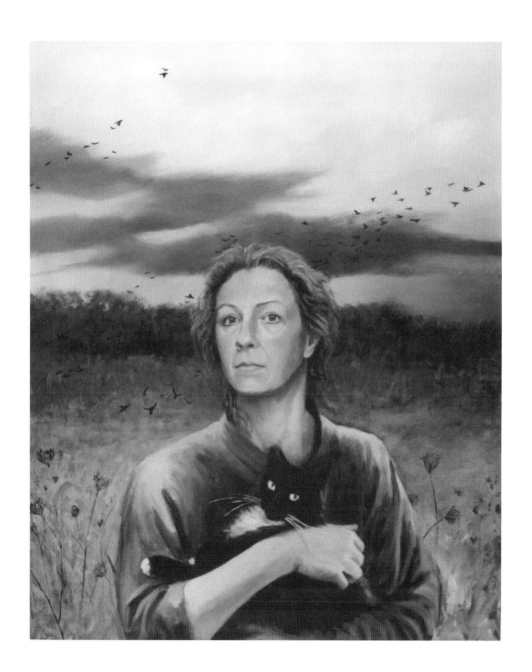

A Note to the Reader

THE PASTELS and oil paintings in this volume were not created for this book or any book. They are just what I do, and I'm fortunate to have them gathered here in one place. I did the earliest piece in 1998 and the latest in 2008. I will undoubtedly make more paintings with cats in them and I'll be sorry they couldn't be included here. I truly love painting cats, even though I know the subject is limited and my personal enjoyment is not always the foremost reason for doing what I do. Their flexible shapes, their oddly formed faces, and articulated legs make up this artist's favorite puzzle. Solving it brings me joy in the studio. And nothing is quite so amazing as how a brushstroke can become the soft tufts of multicolored fur along a flank or shoulder. Although most of the cats depicted here belong or have belonged to me, a few belong to friends; and the orange one, Soupcon, is one of my mother's three cats. I have spent more time than I care to admit traipsing behind busy cats trying to take photographs from which to base sketches. It's humbling and frustrating work. They never perform as desired. But their shapes are unmistakable and completely beautiful as they are, so one has to get them right. Although I've used pastel for half of these works, it is oil that really captures the sensuality of these animals for me. And perhaps it is because the medium of oil paint is as mysterious as the subject of the cat—deep, alive and to some extent uncontrollable. The alchemical qualities of oil paint, its characteristic of magical transformation, turning strokes of color into substance, are much like the cat, liquid and solid mingled, and with layers beyond our consciousness. Cats and oil paints will forever intrigue me.

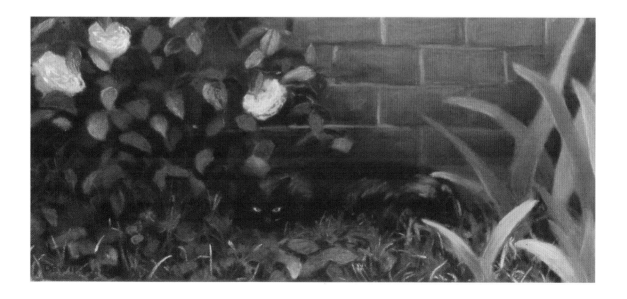

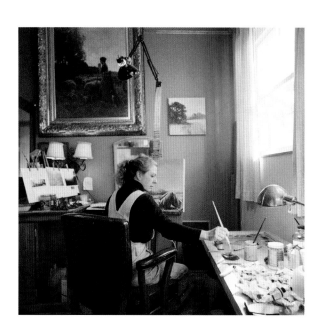

ABOUT THE AUTHOR

BORN IN 1956, Deborah is a fifth-generation artist, a descendant of Dutch illustrators and painters. Self-taught, she has been making images, initially as a photographer, since she was 15 years old. After abandoning a college major in agricultural science, she traveled to many places, capturing light on film while exploring the world. She moved into pastel in her twenties and on to oil a few years later. She is the author of *Traveling Light: Chasing an Illuminated Life*, a photo-illustrated written chronicle of her young years as a photographer and developing artist. Her interest in books as an expression of the human experience led to many paintings and pastels about reading and the pursuit of knowledge. Many of these works have been collected in the book *Deborah DeWit Marchant: In the Presence of Books*. Her artwork can be found in private, public and museum collections across the country and has been used on the covers of books and magazines, in calendars and on cards. Deborah and her husband Robert live and work with their three cats and their nine pigeons in a suburb of Portland, Oregon.

Her web site is www.dewit-marchant.com.

ACKNOWLEDGMENTS

If a book is a kind of performance, there is always a hidden cast of characters backstage. They watch, they encourage, they lower the lights or they spotlight a scene, they make the marks on the floor, they move props in and out, they help the actors make wardrobe changes. They know the words by heart but never get to speak them, or take a bow at the end. I would like to thank these people who sit in the wings of this book: Tom Sumner, Julie McCoy, Carl Vandervoort, Olivia Dresher and Duffie Bart. Jim Leisy, my publisher, has drawn open the curtains. And my beloved husband, Bob, has listened to each word and watched each brushstroke, witnessed each rehearsal, with a clear head and an open heart. Finally, sharing the stage and deserving equal billing are the cats who have inspired me and continue to bring joy to my life.

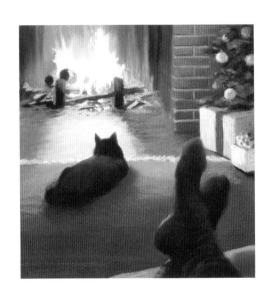

THE END